GW01454405

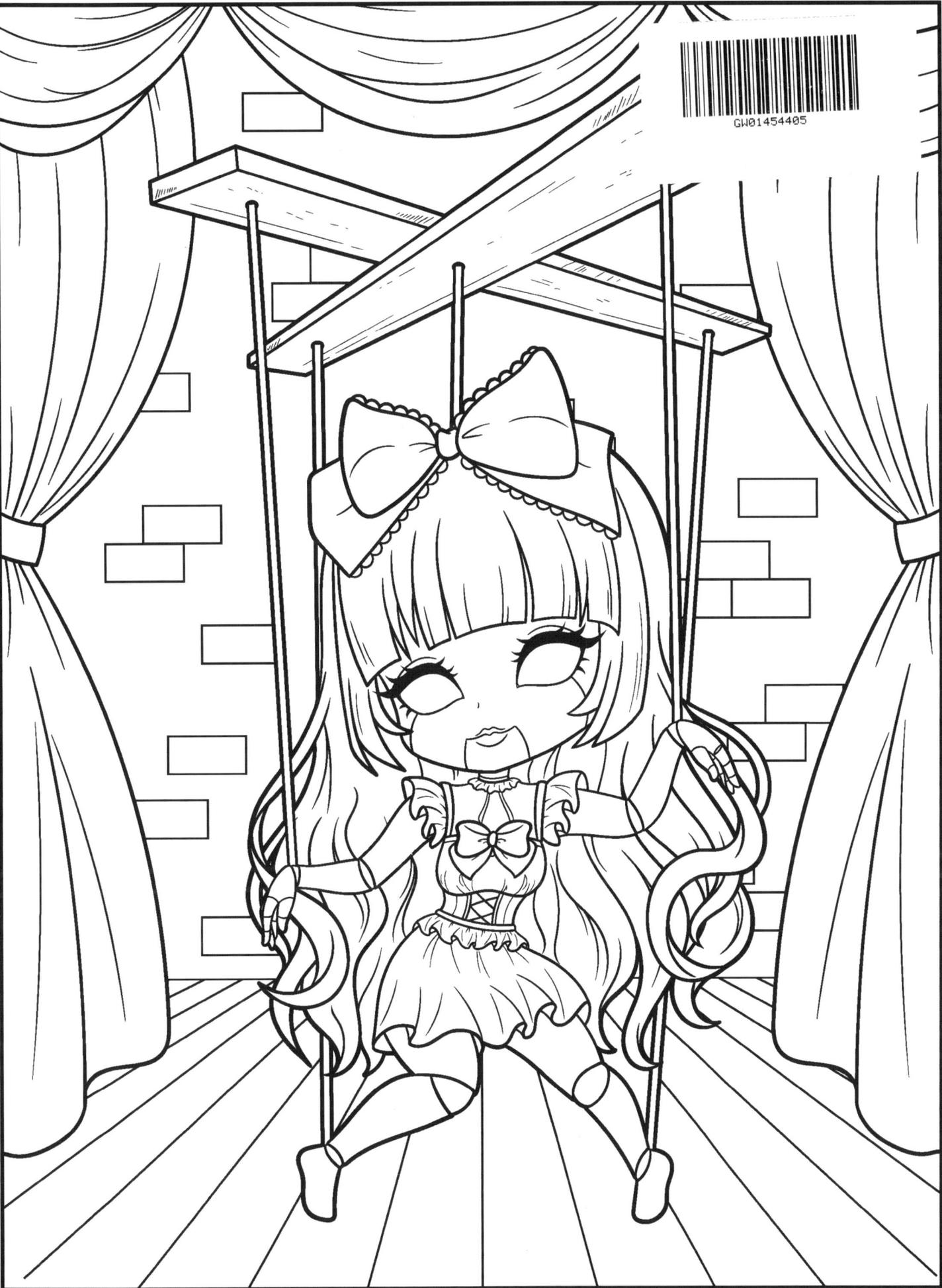

Creepy Chibi Coloring Book © 2021 by CC Coloring
Art by : Leriza May Marinās

All rights reserved. No part of this book may be used or reproduced in any manner whatsoever without written permission except in the case of brief quotations embodied in critical articles and interviews.

First edition: 2021

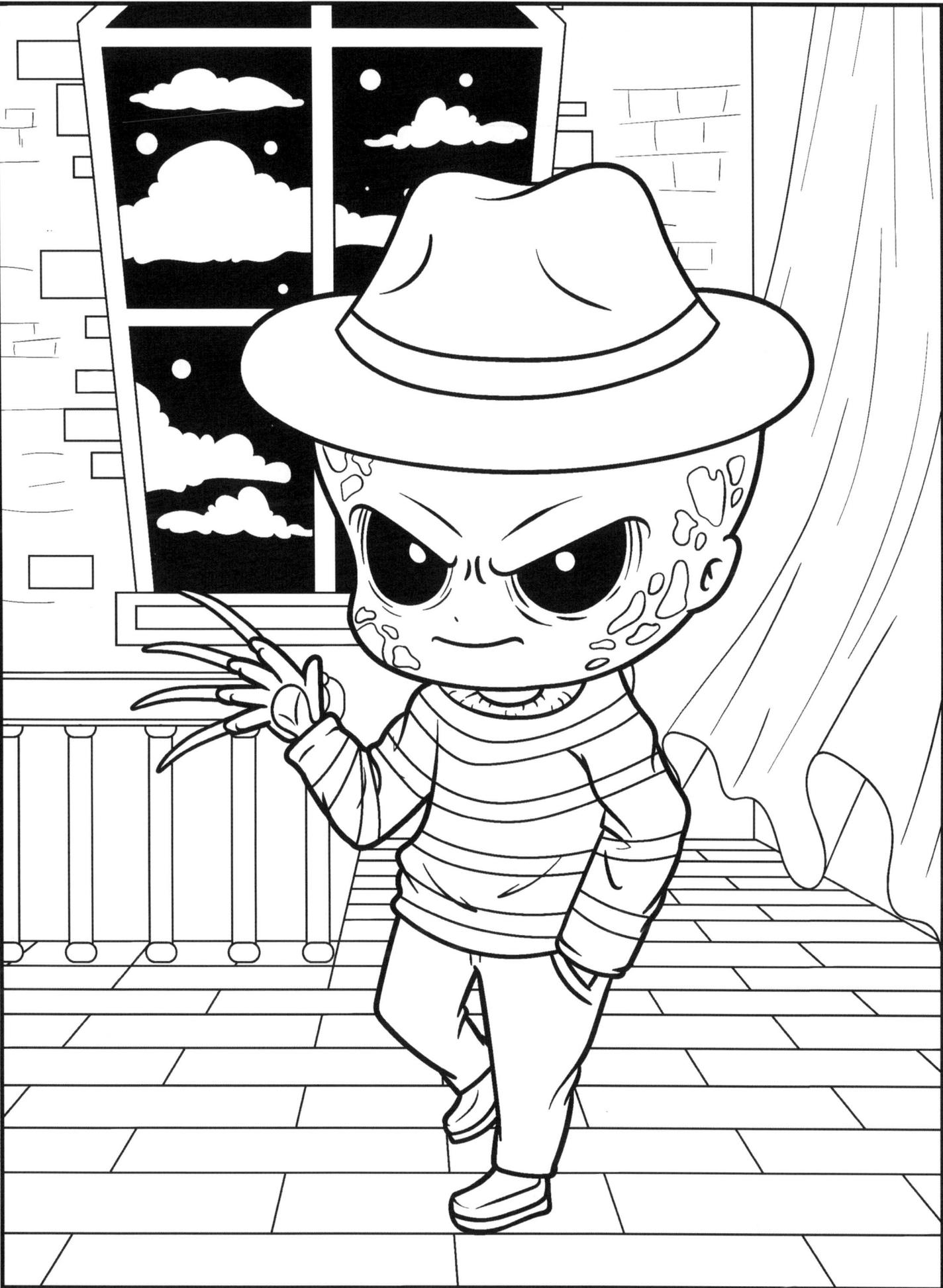

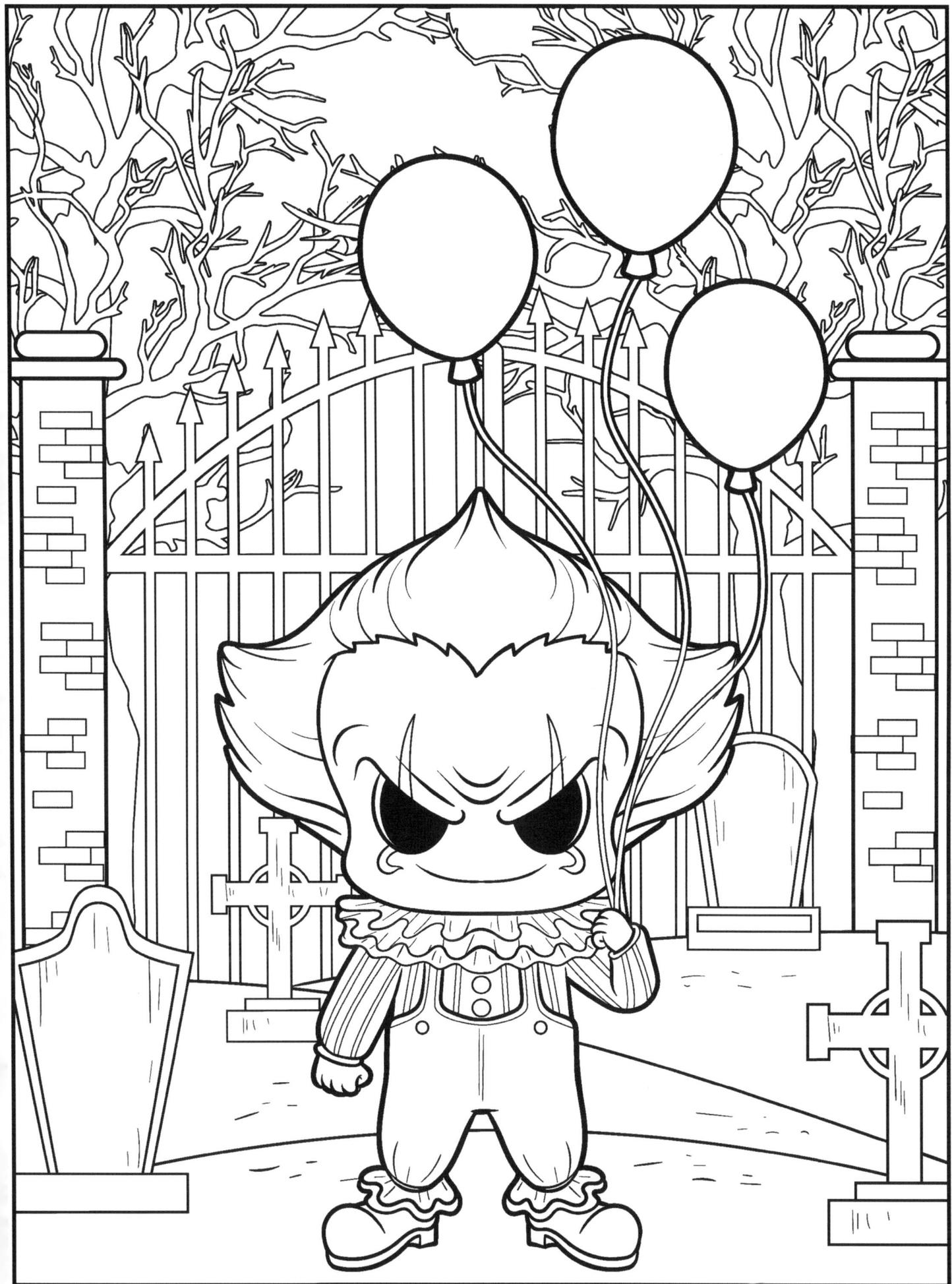

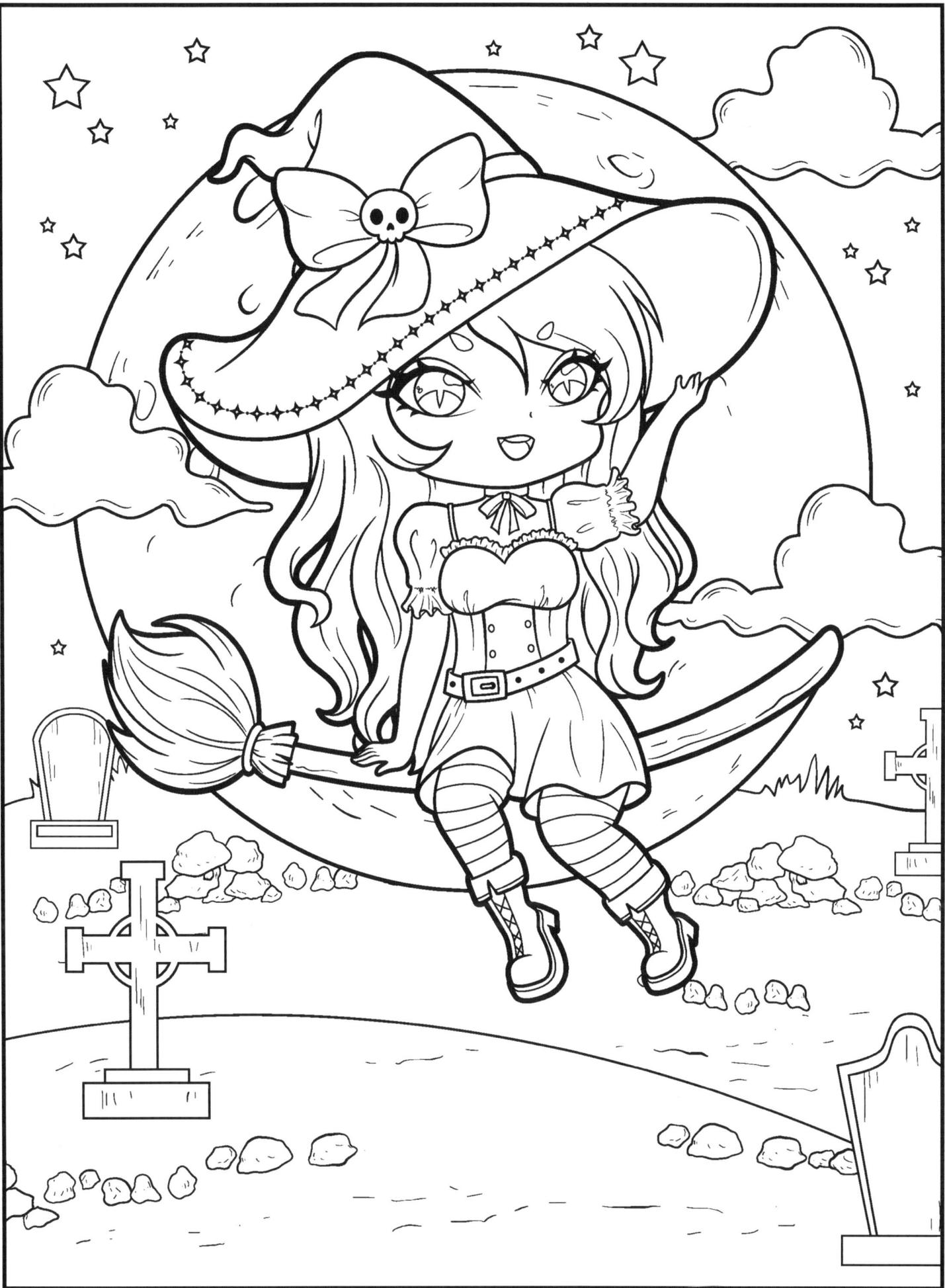

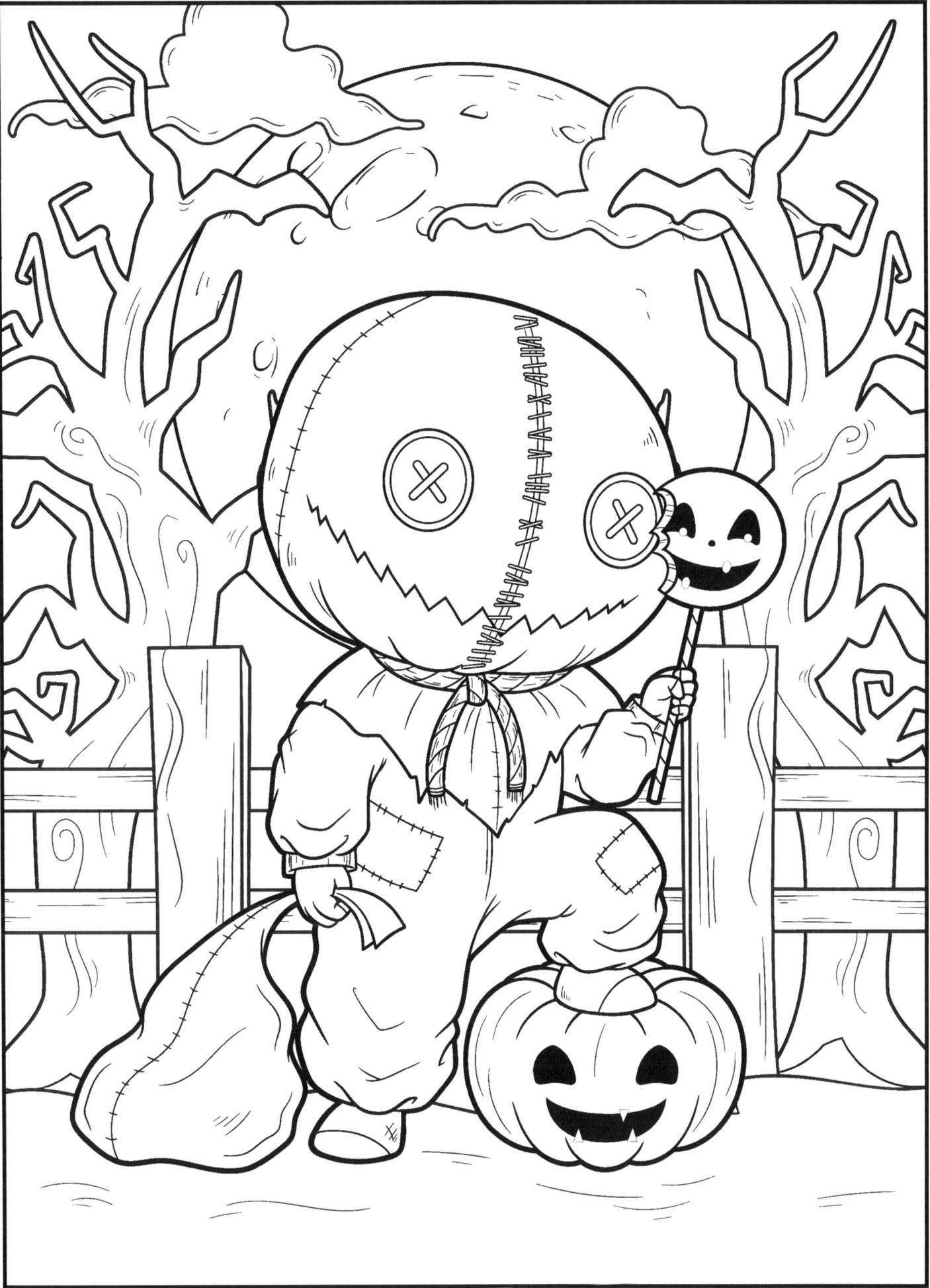

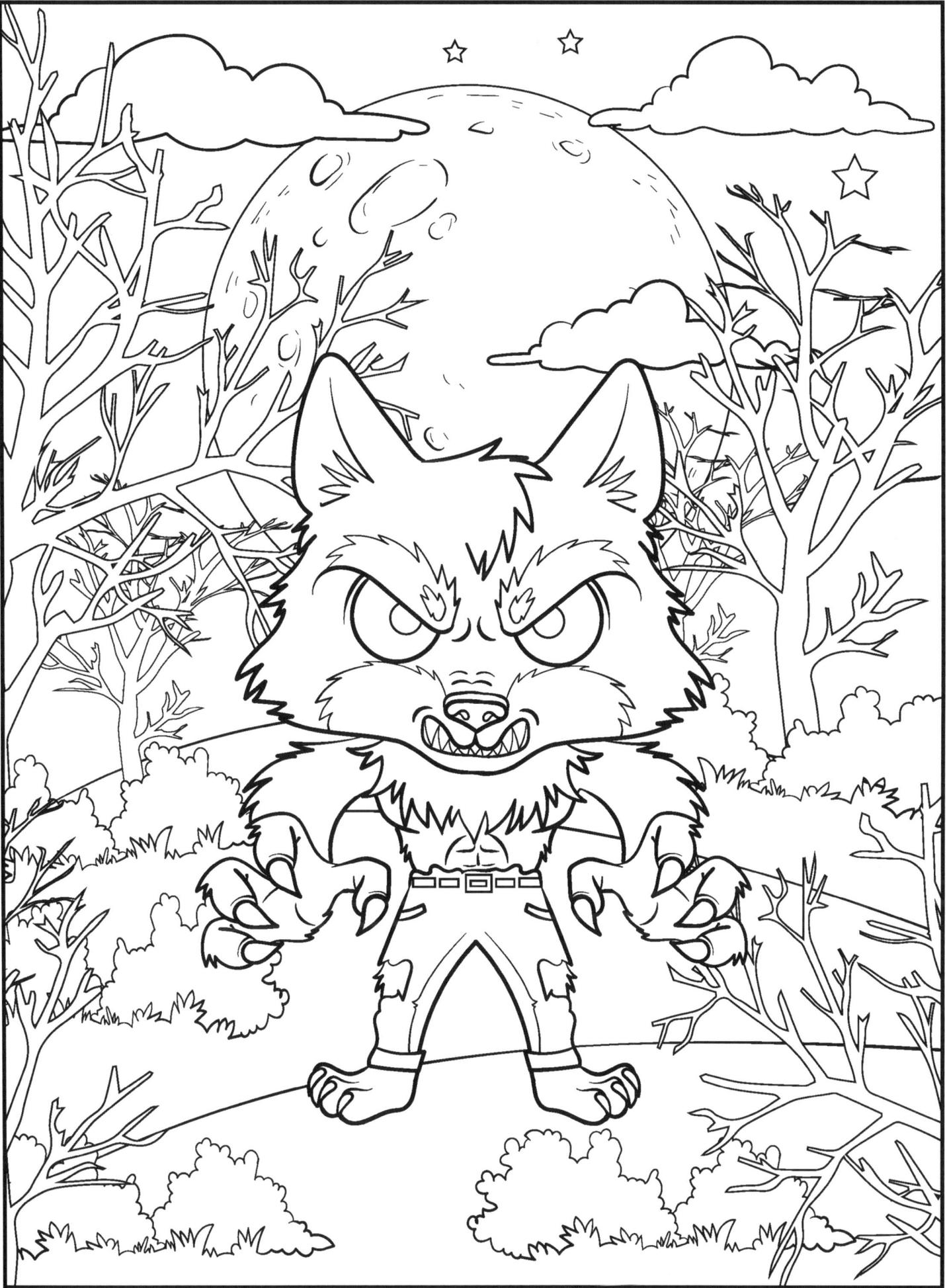

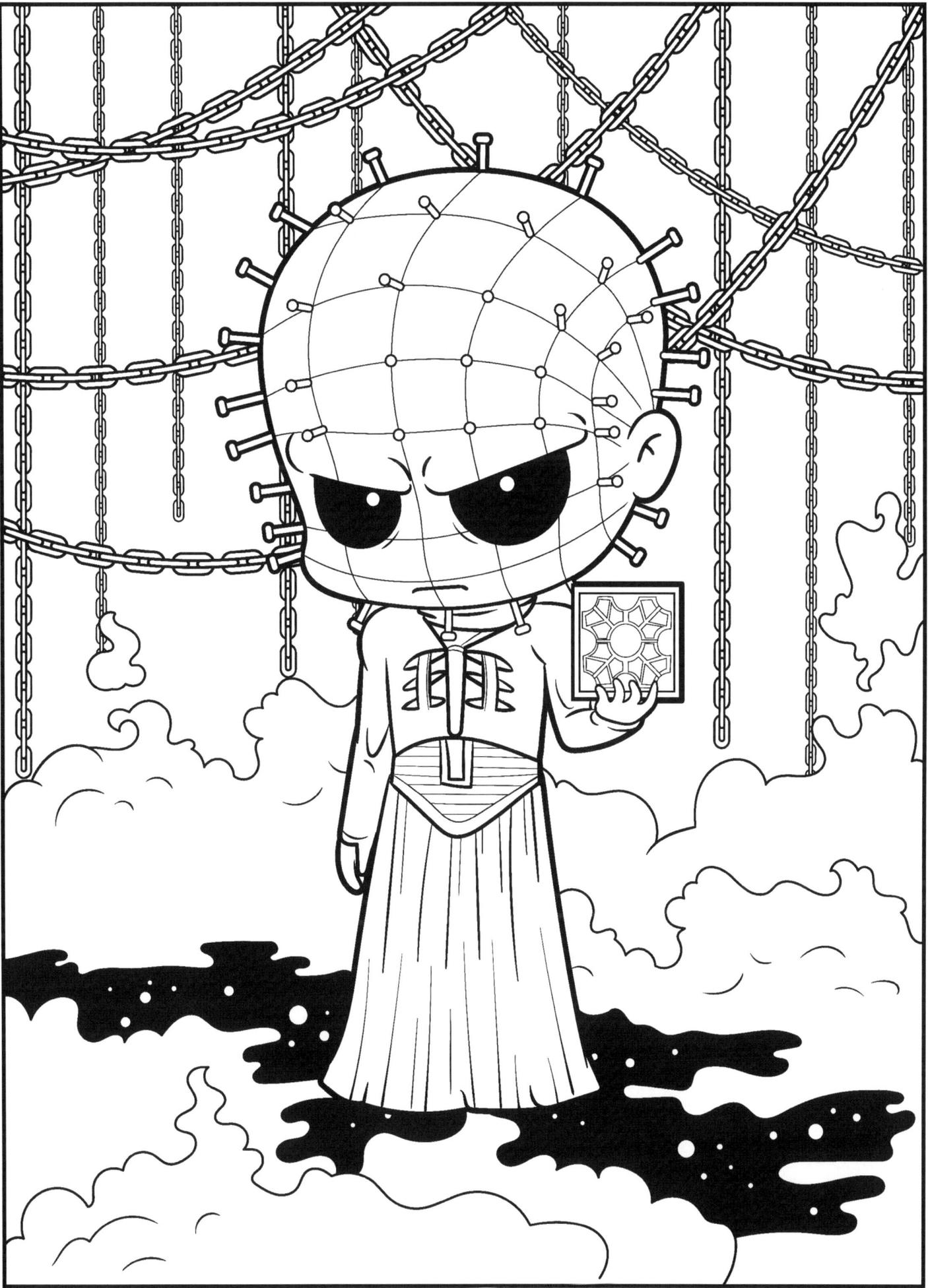

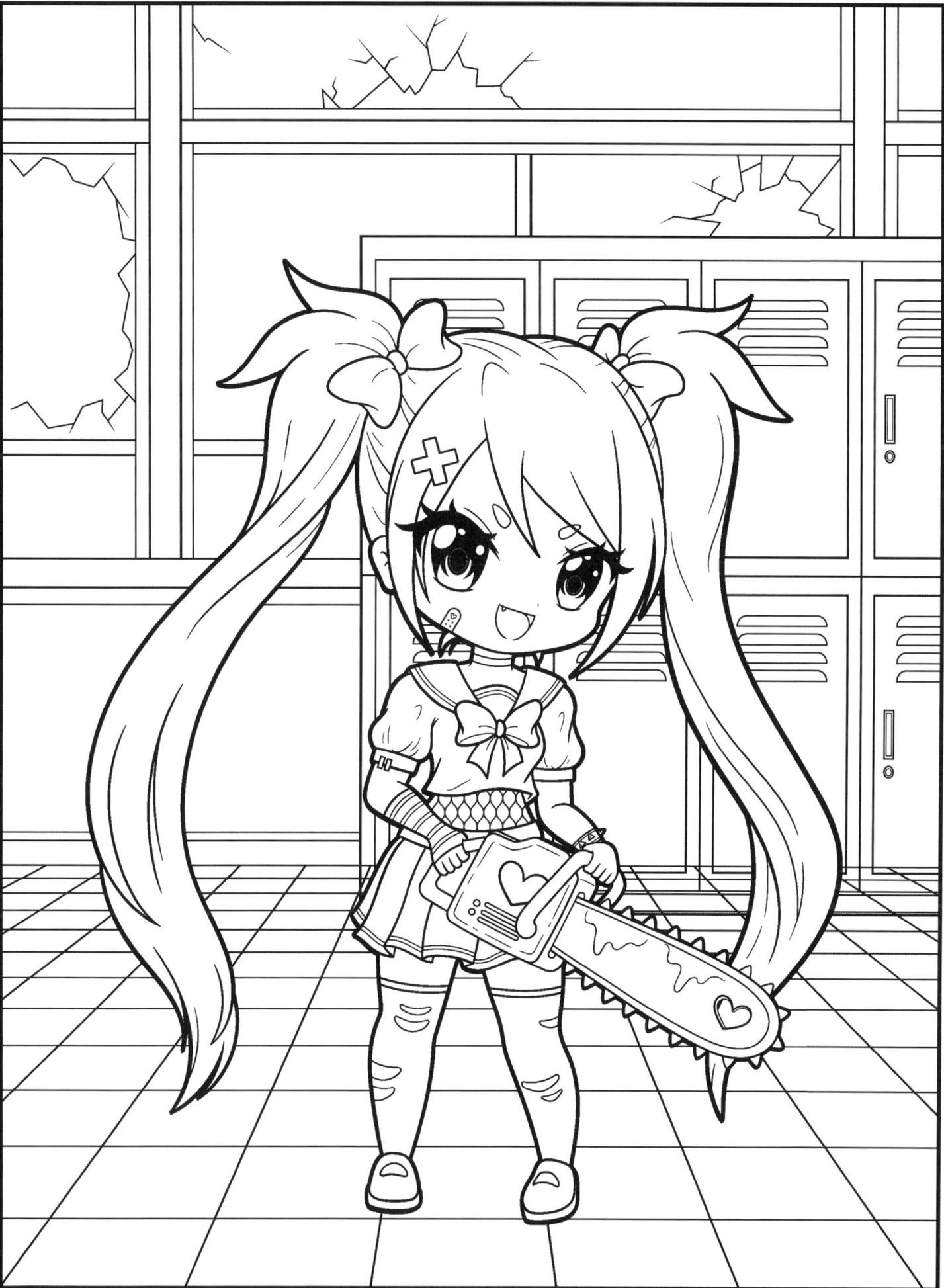

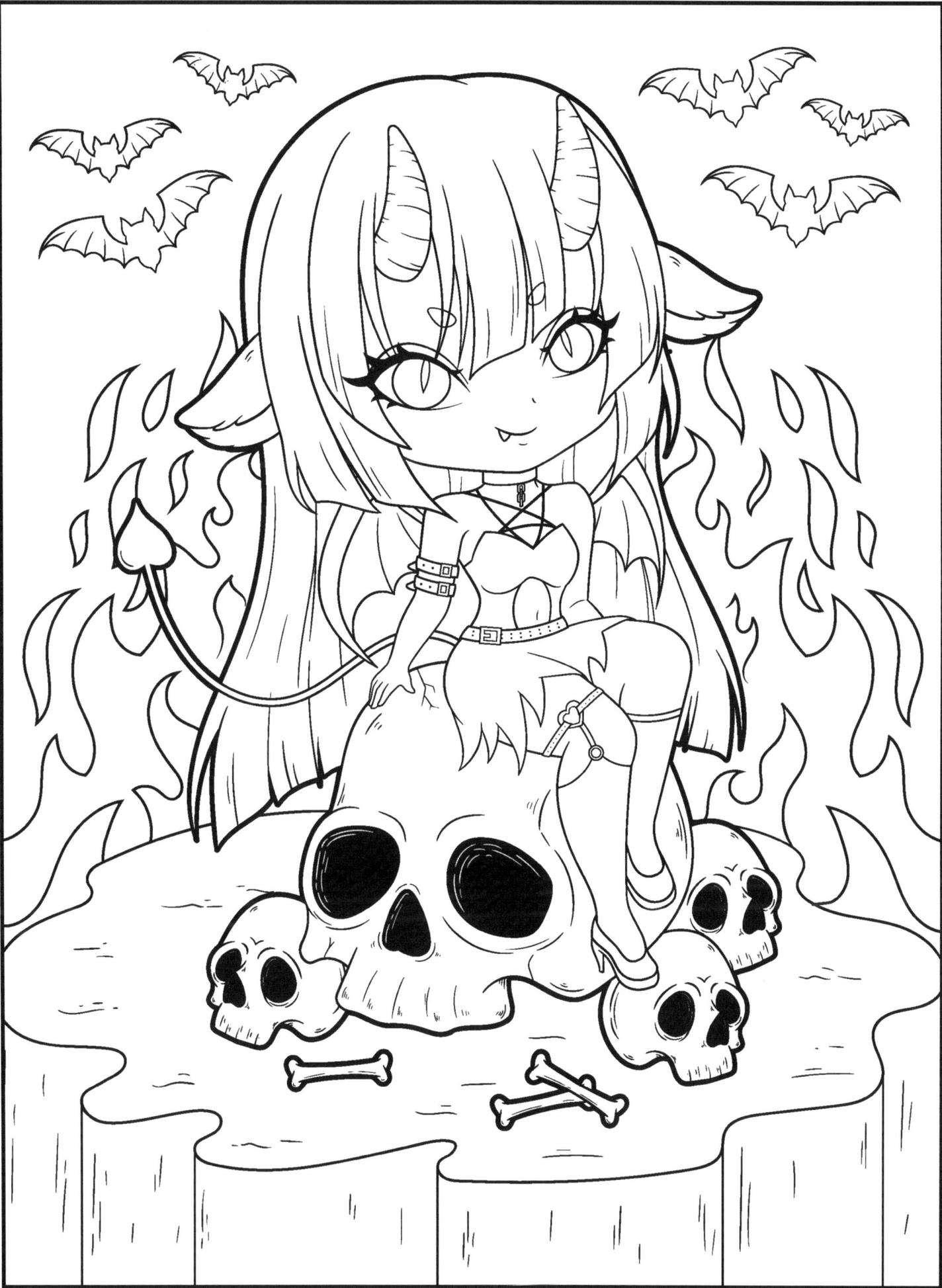

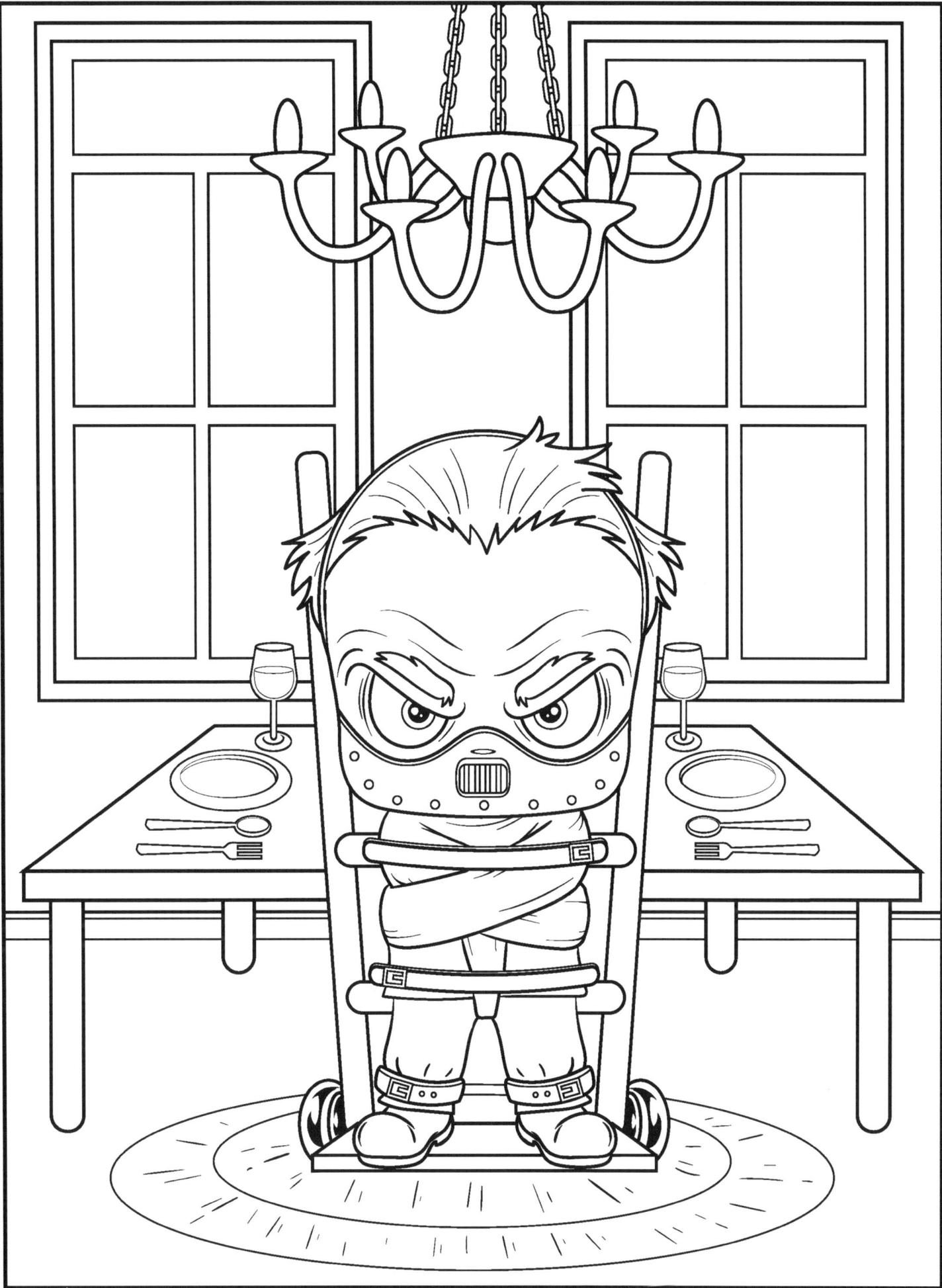

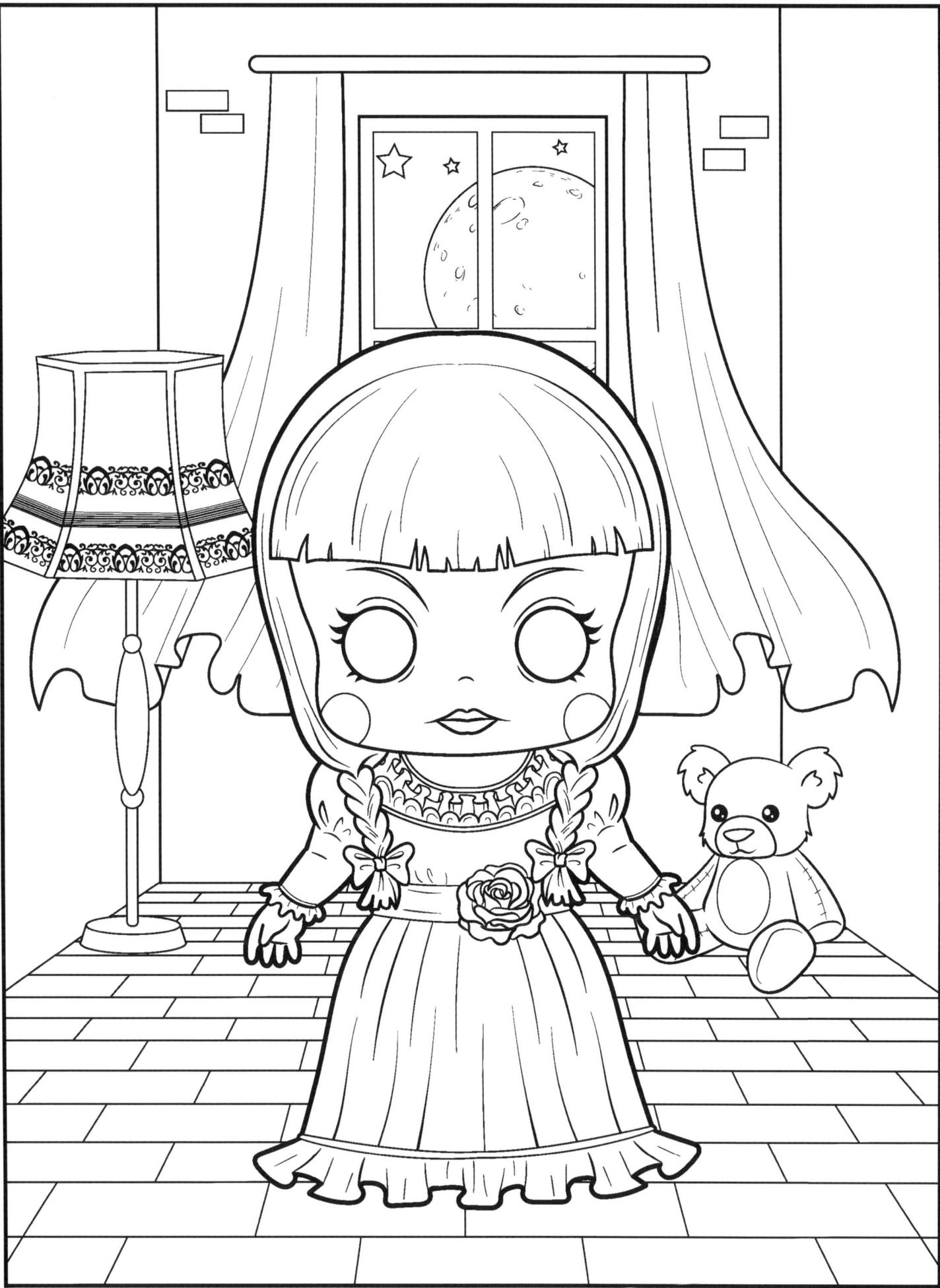

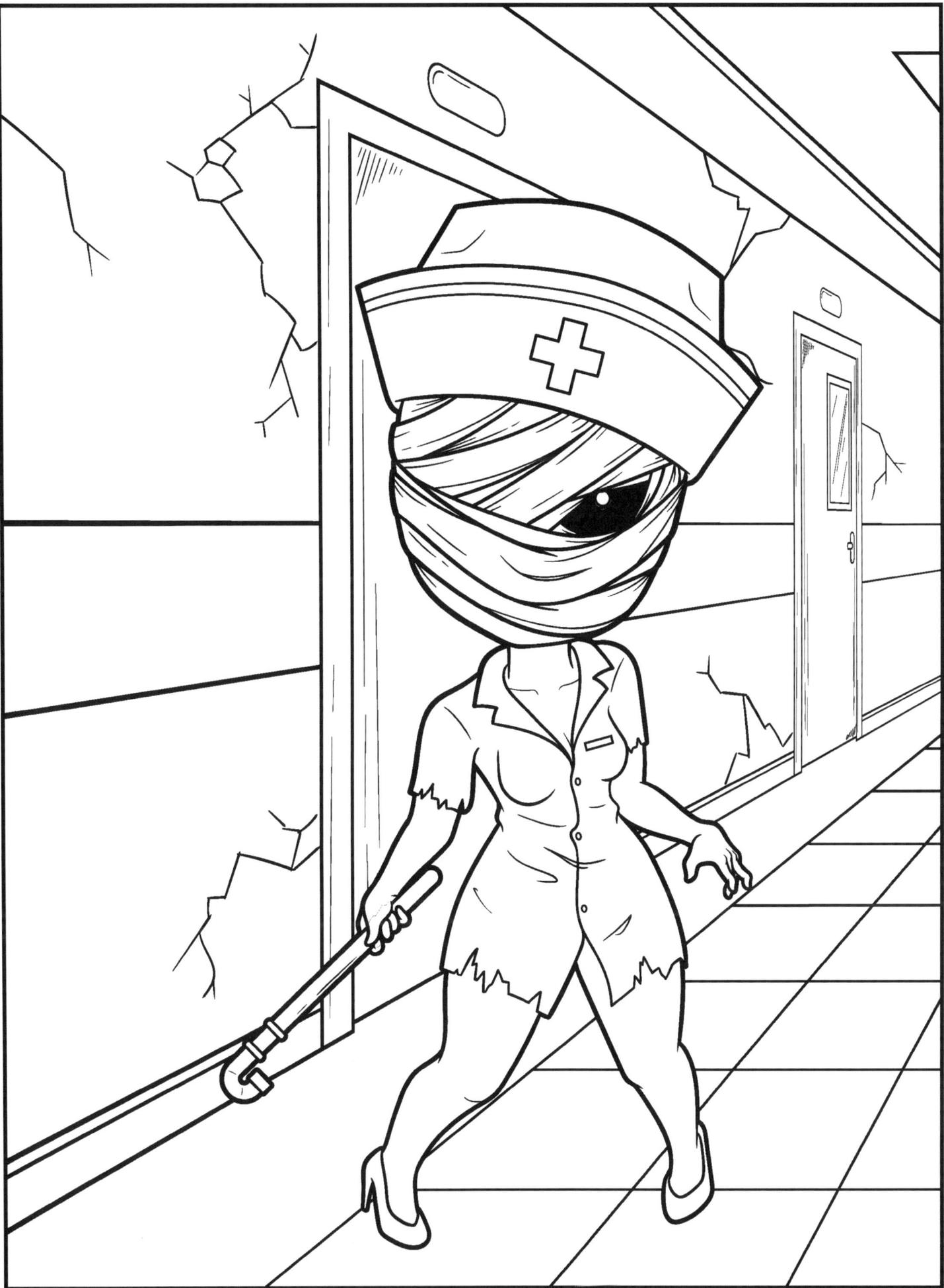

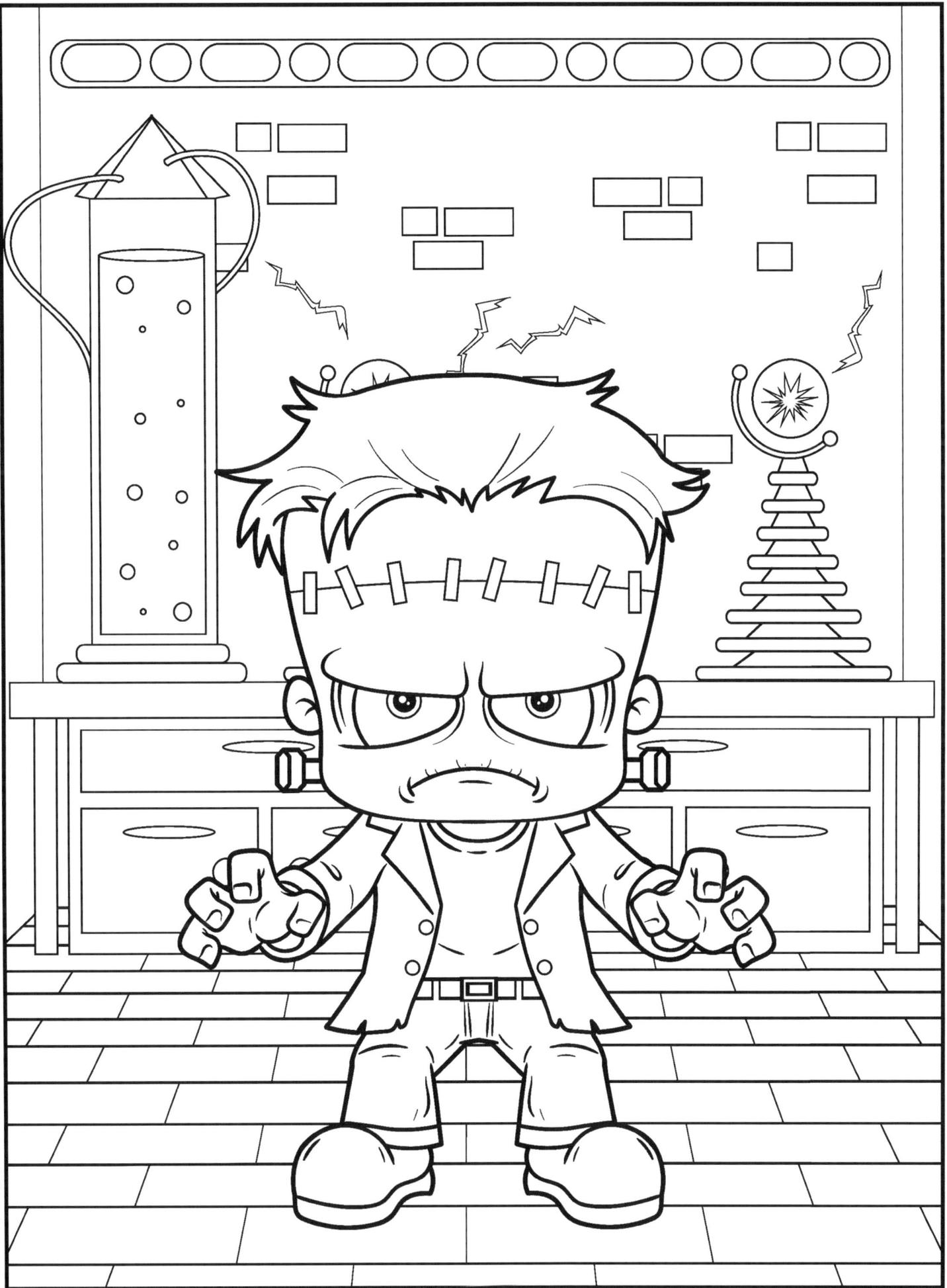

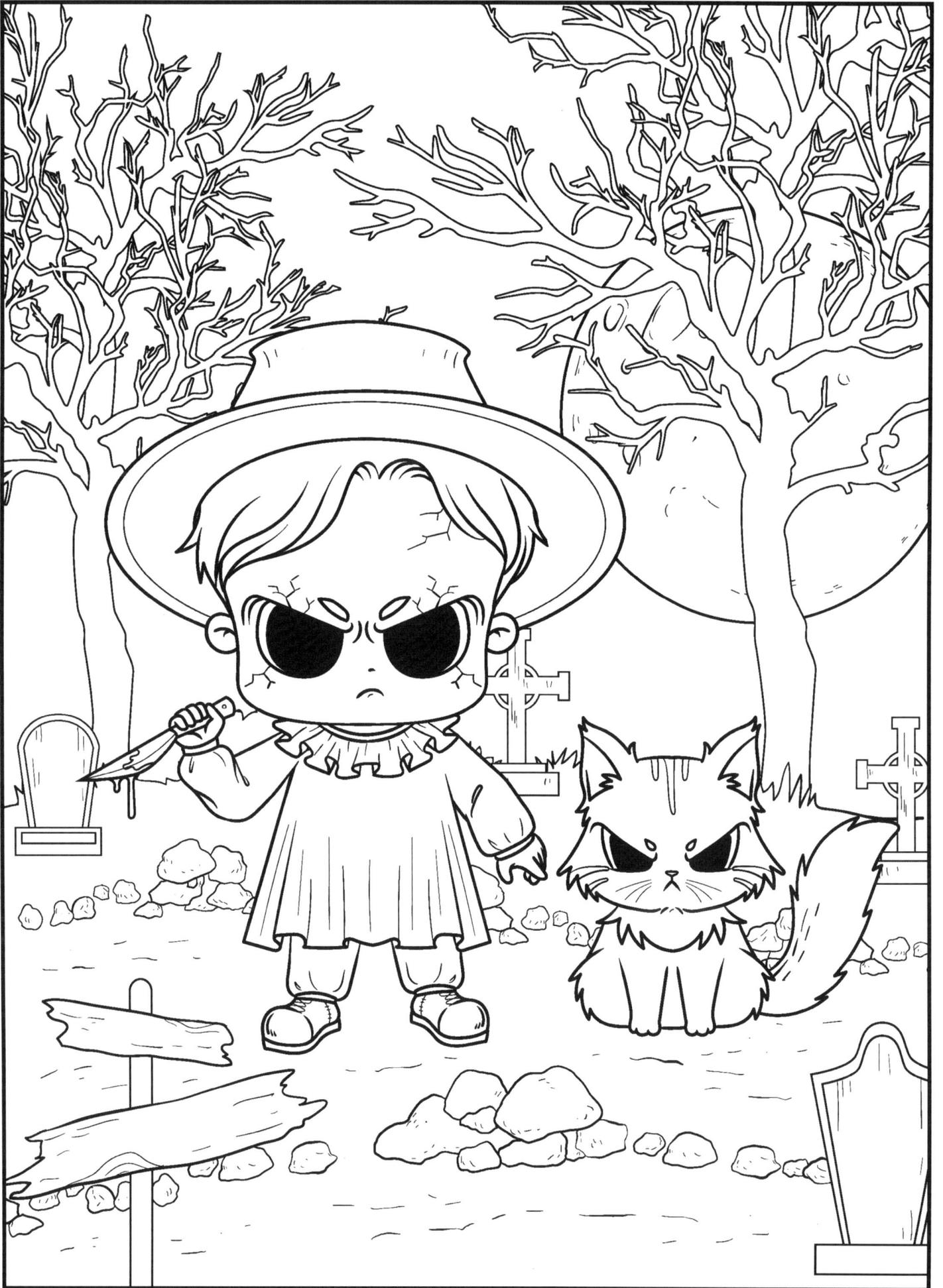

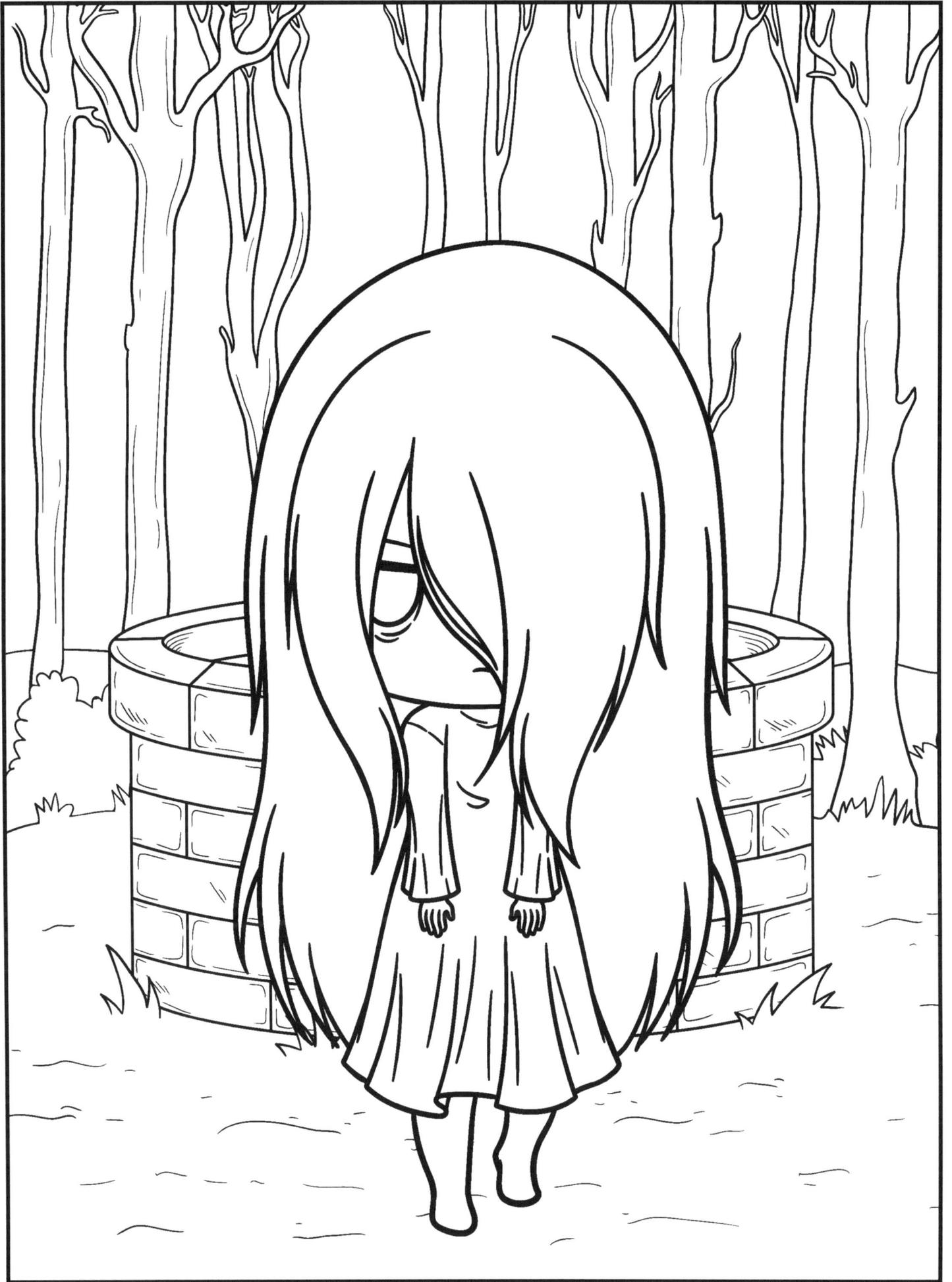

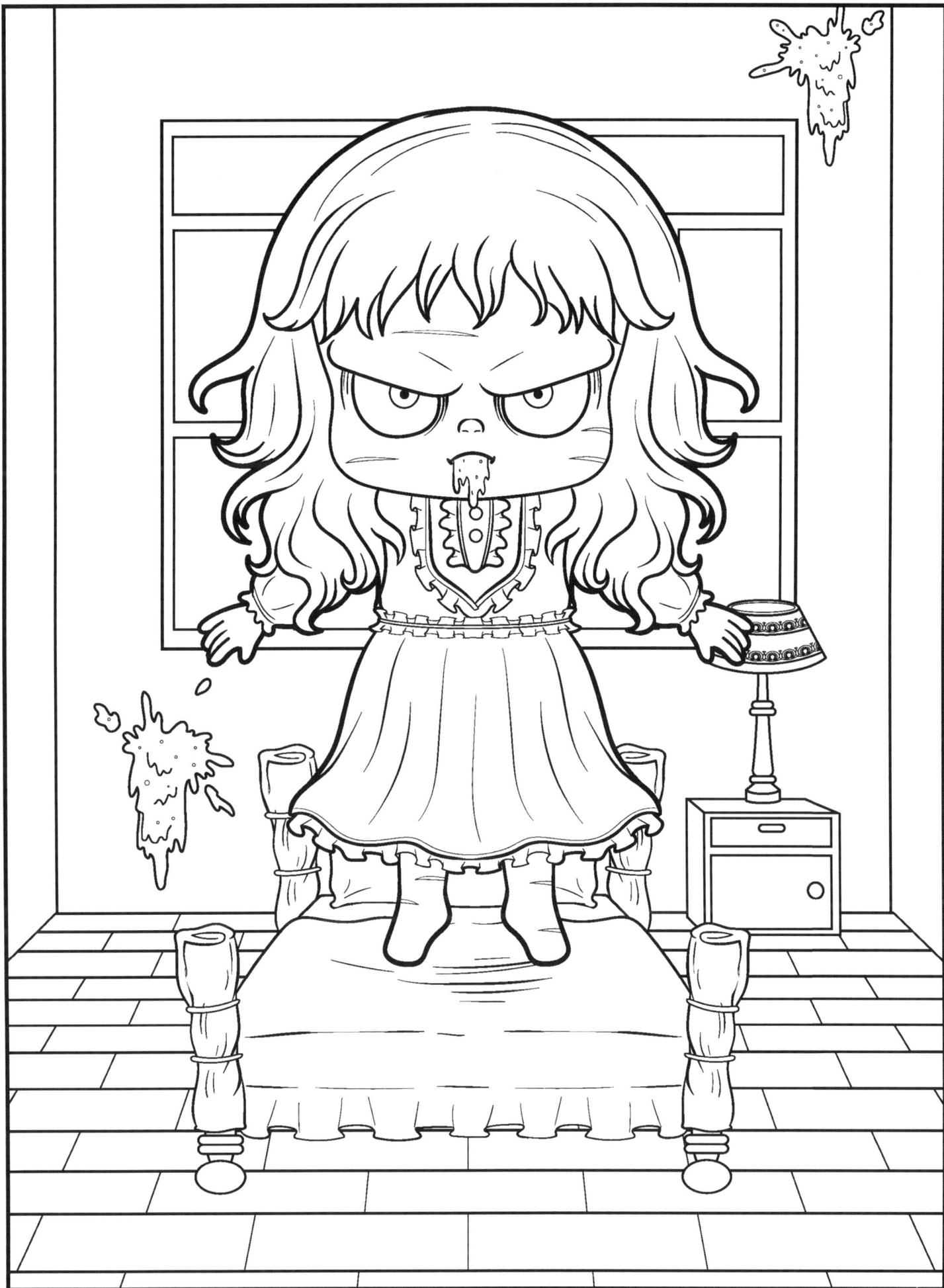

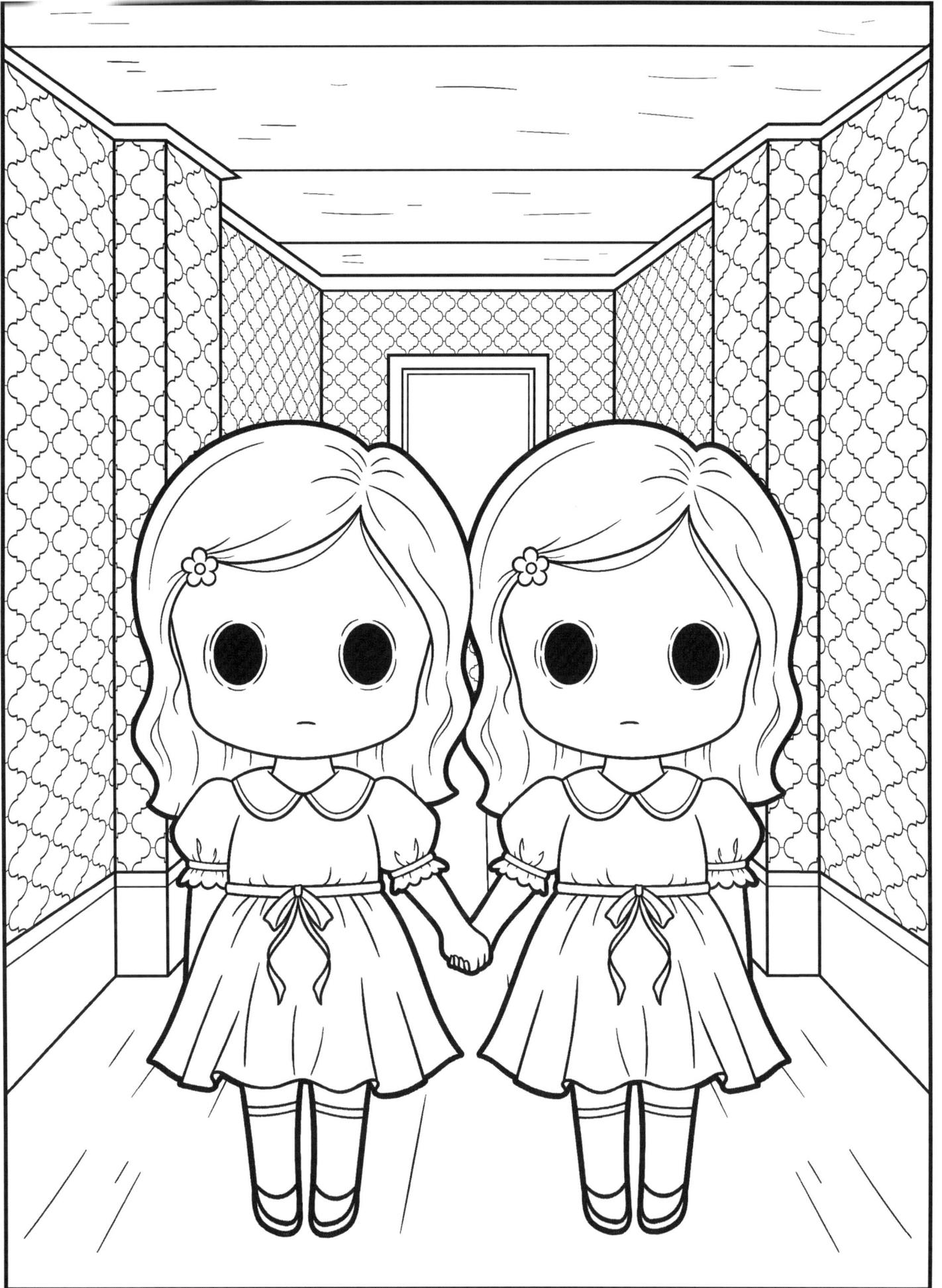

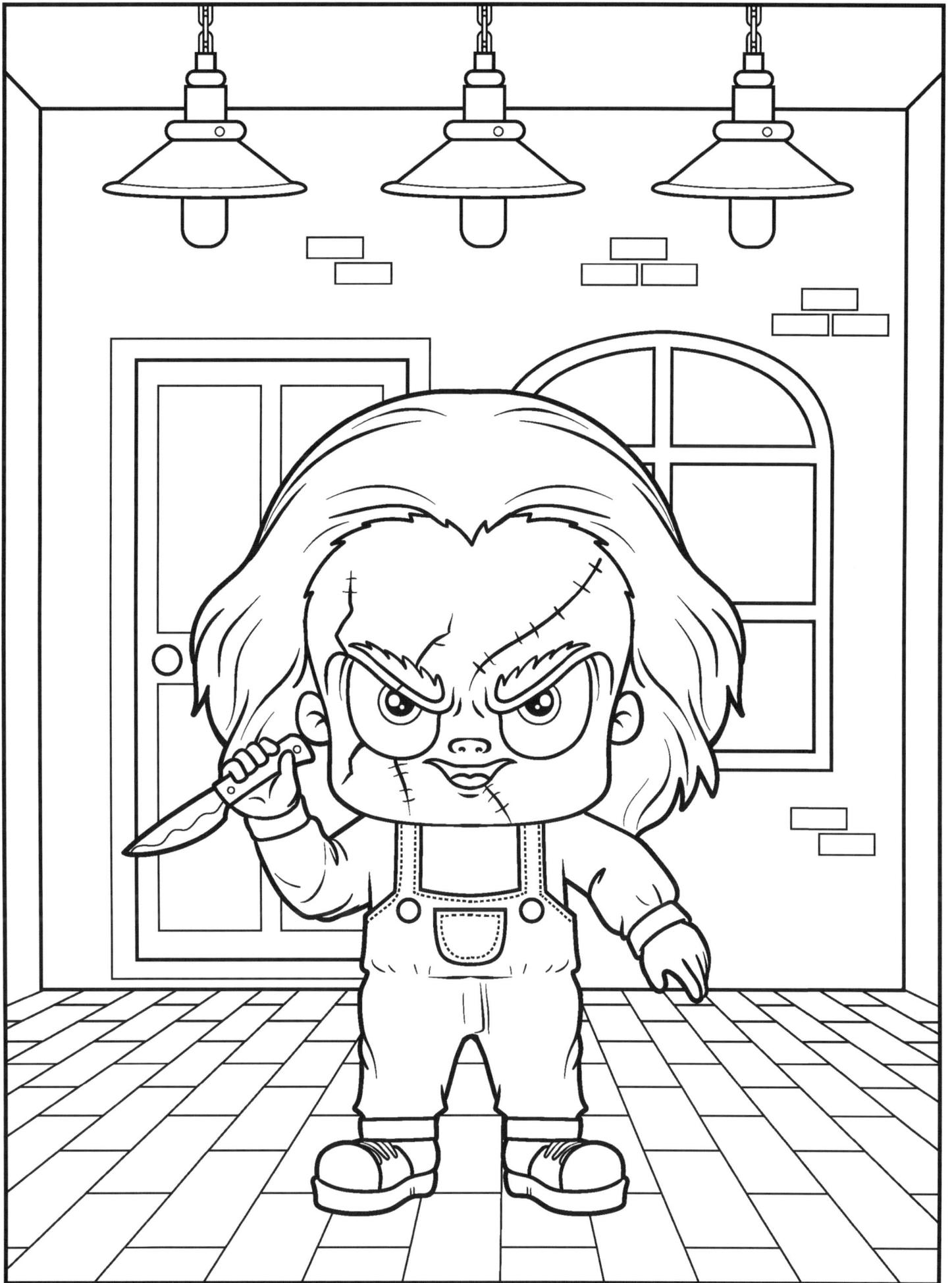

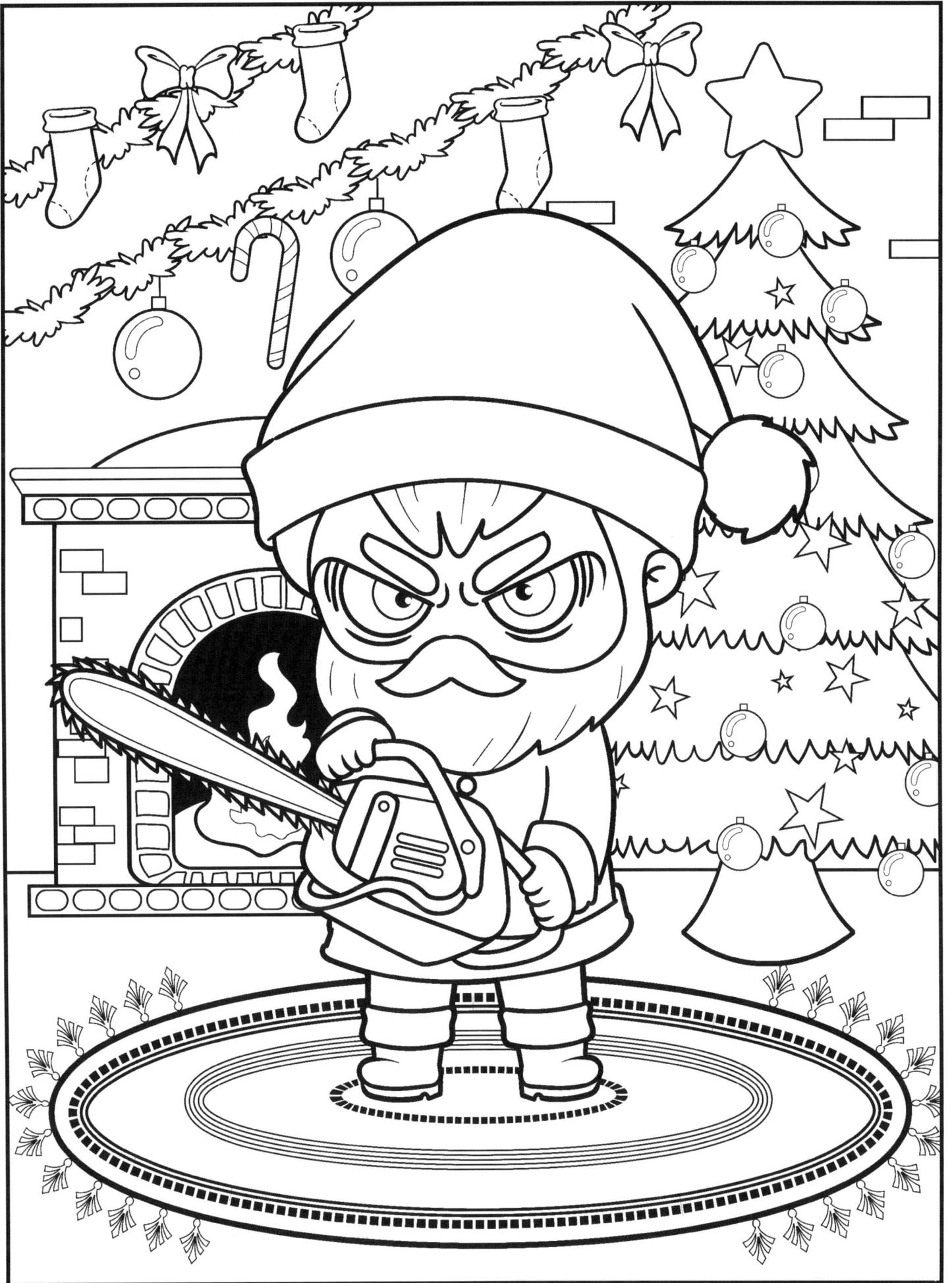

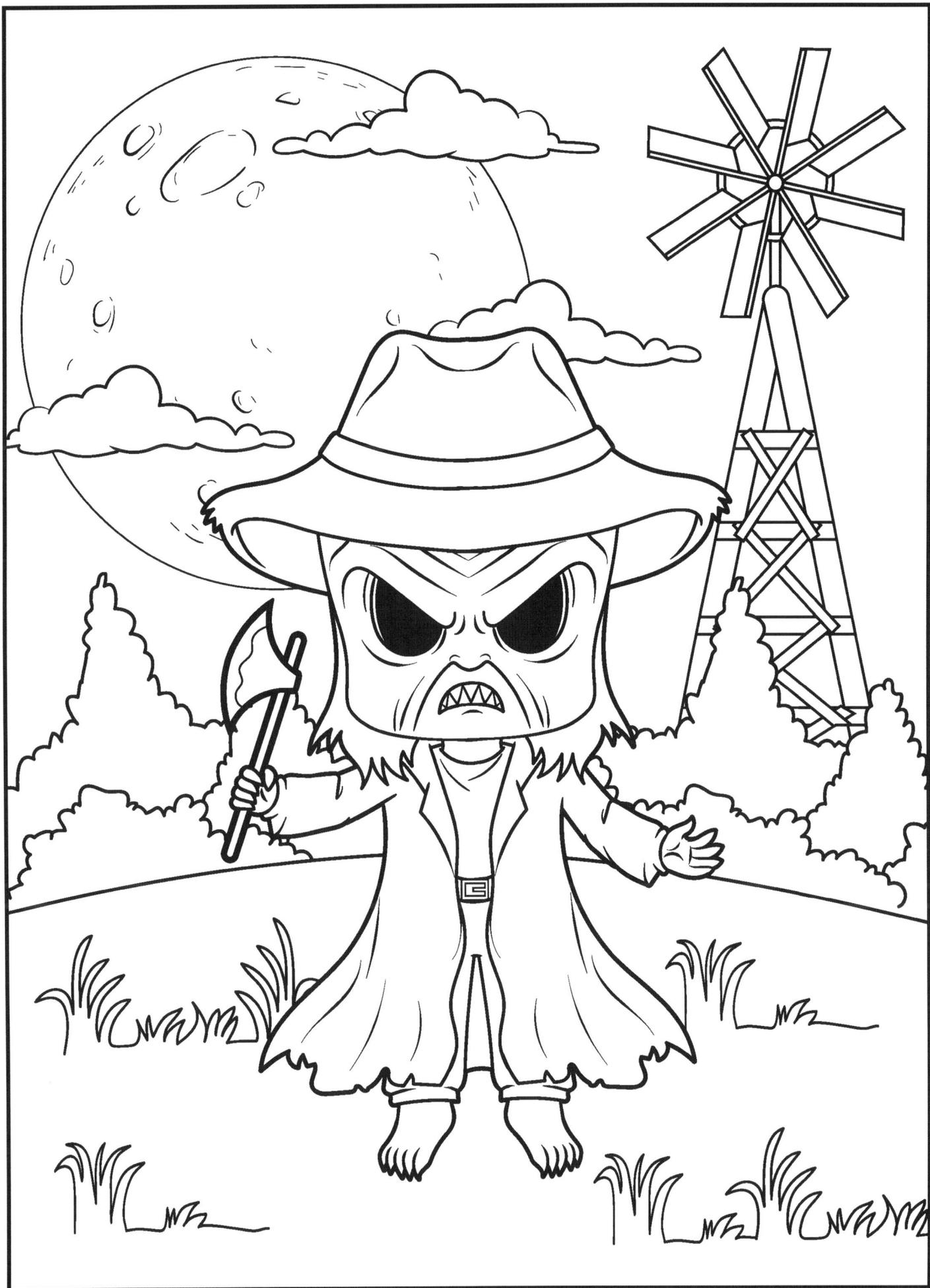

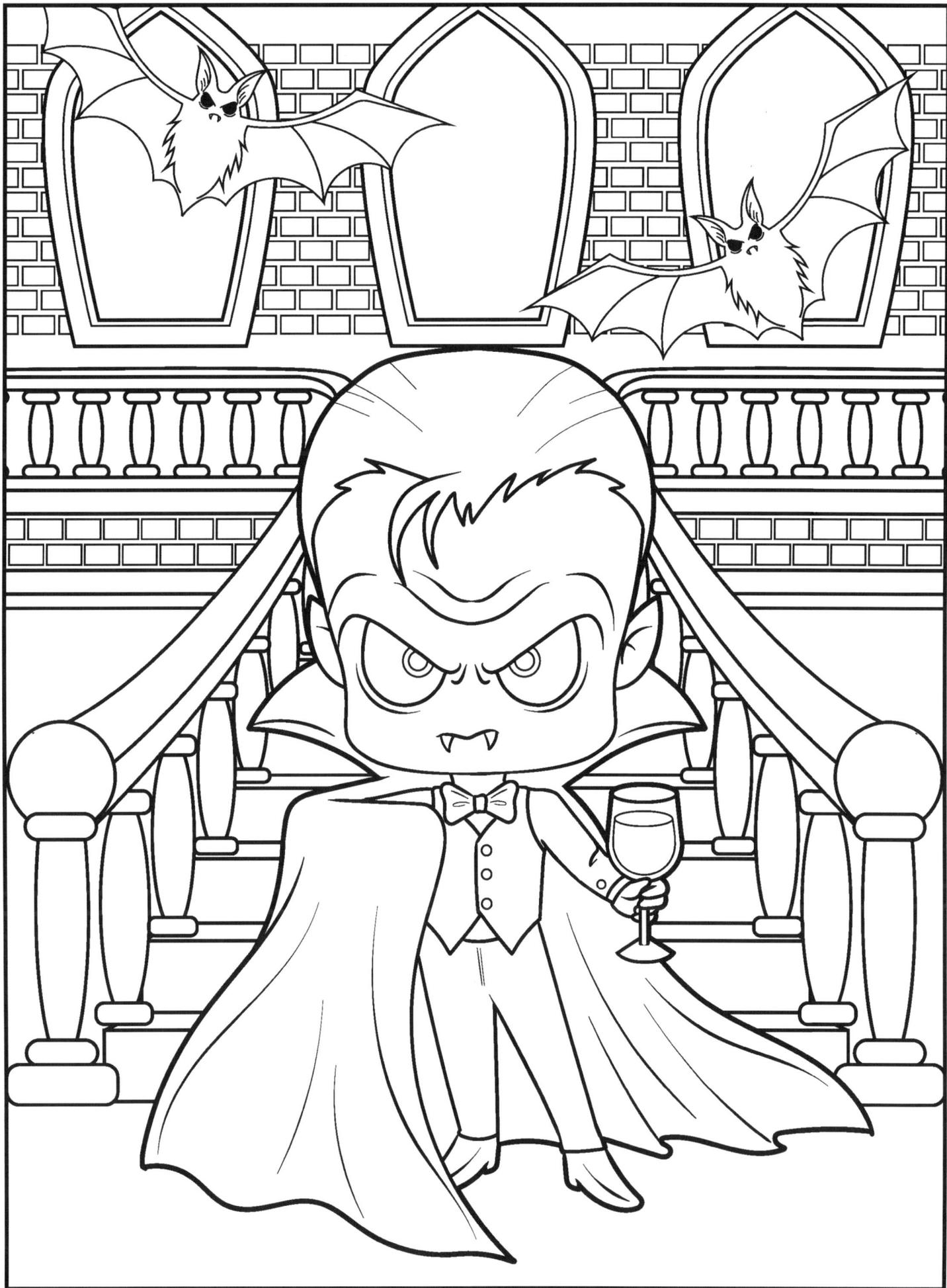

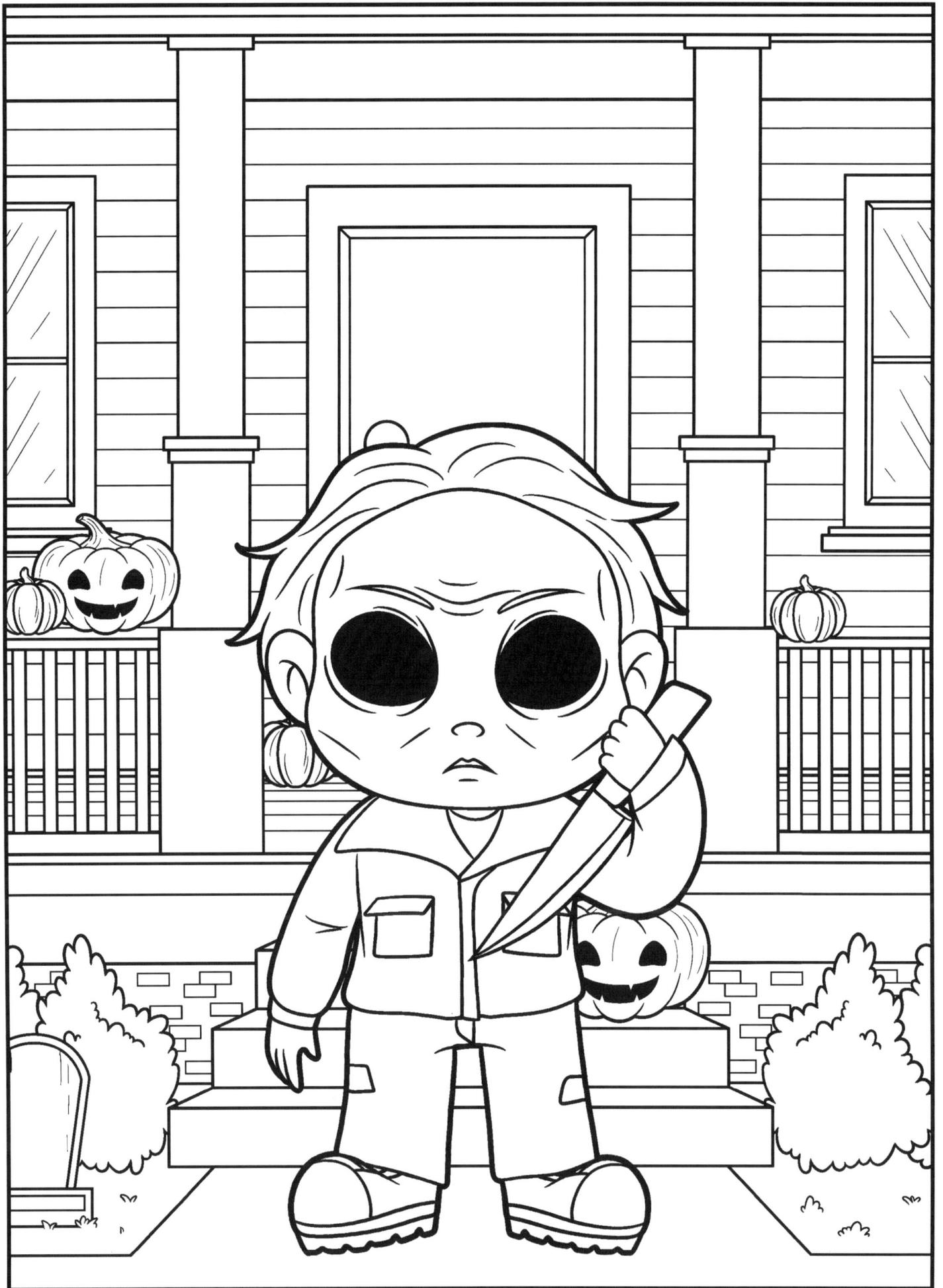

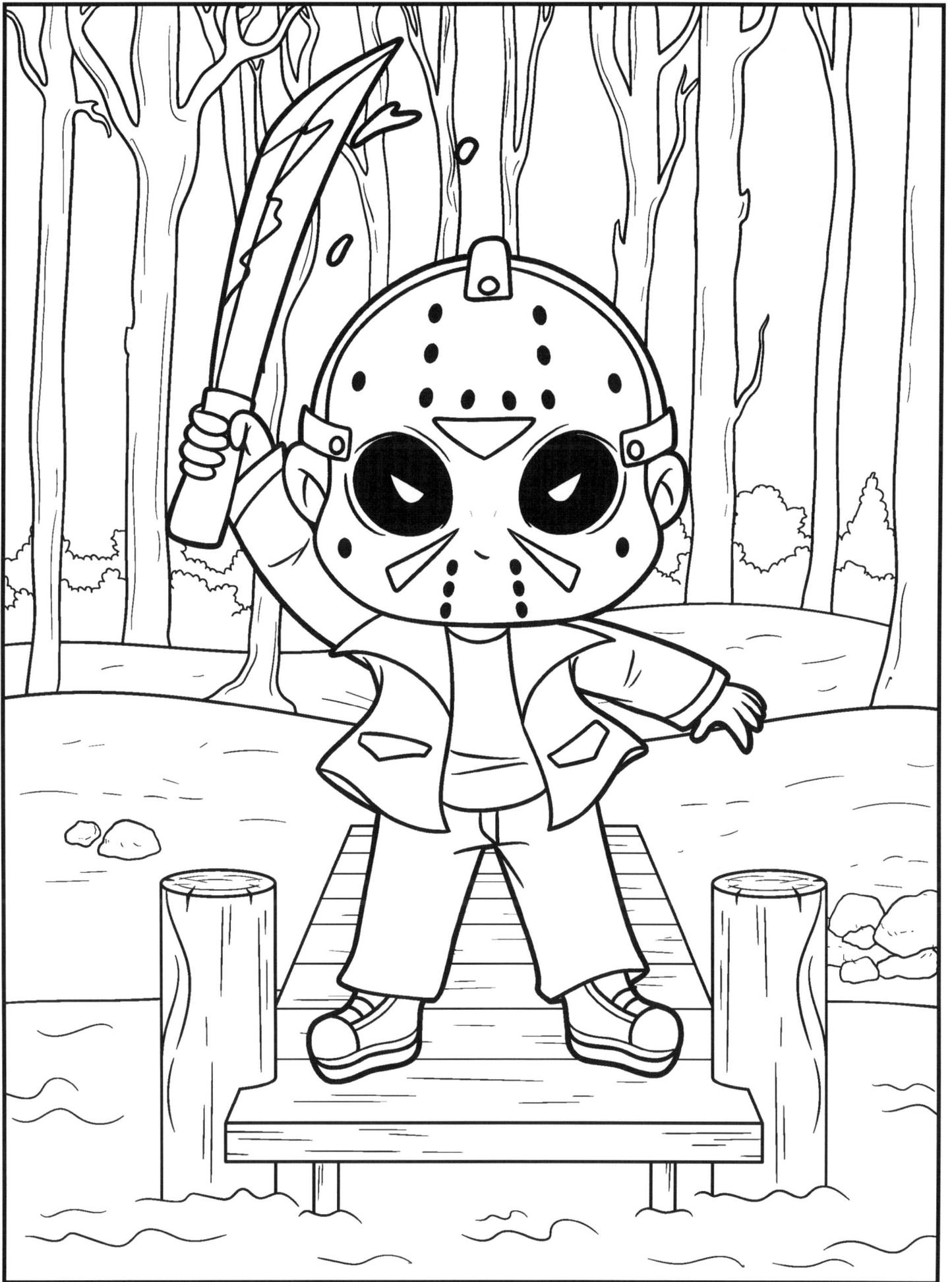

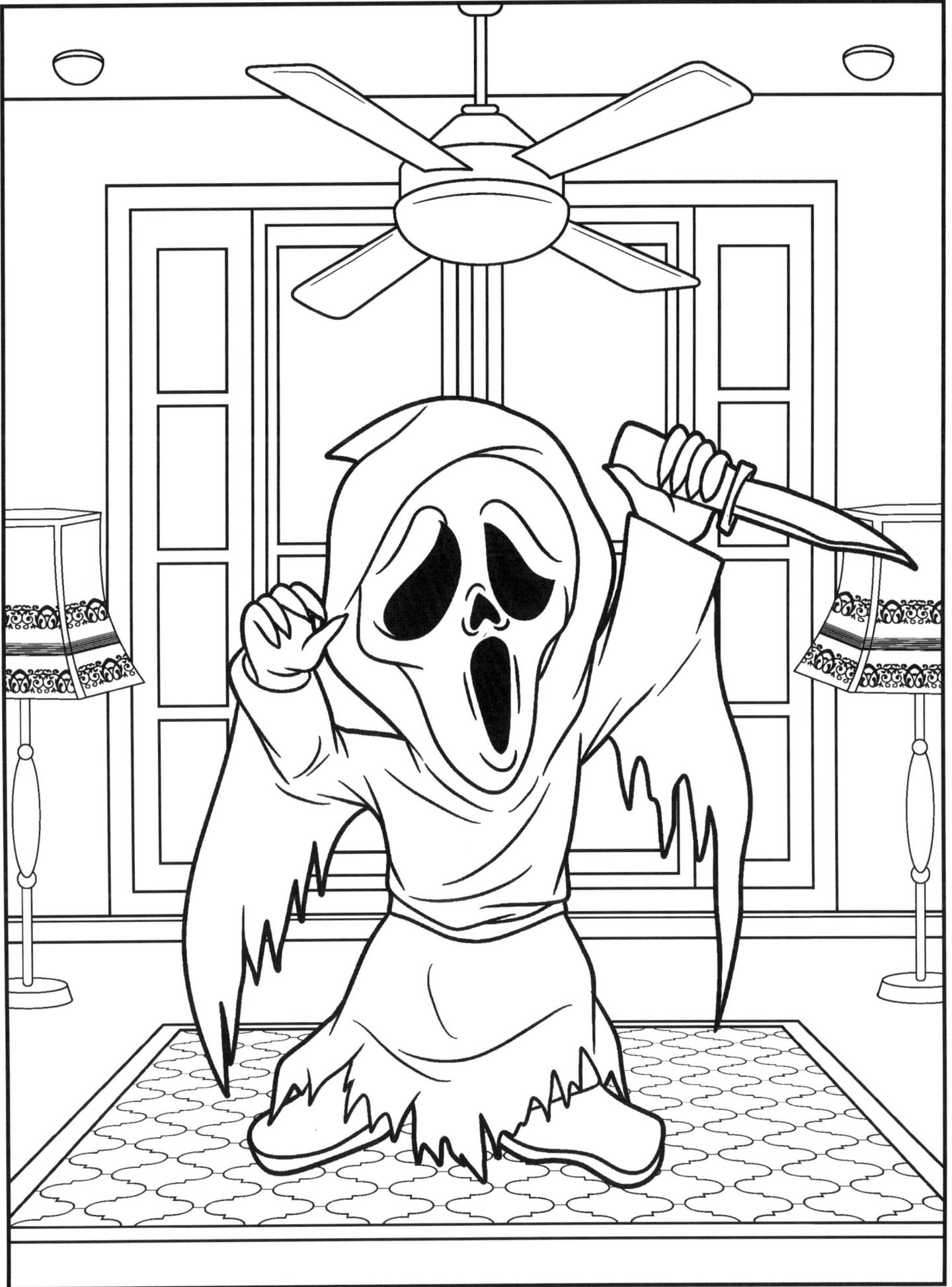

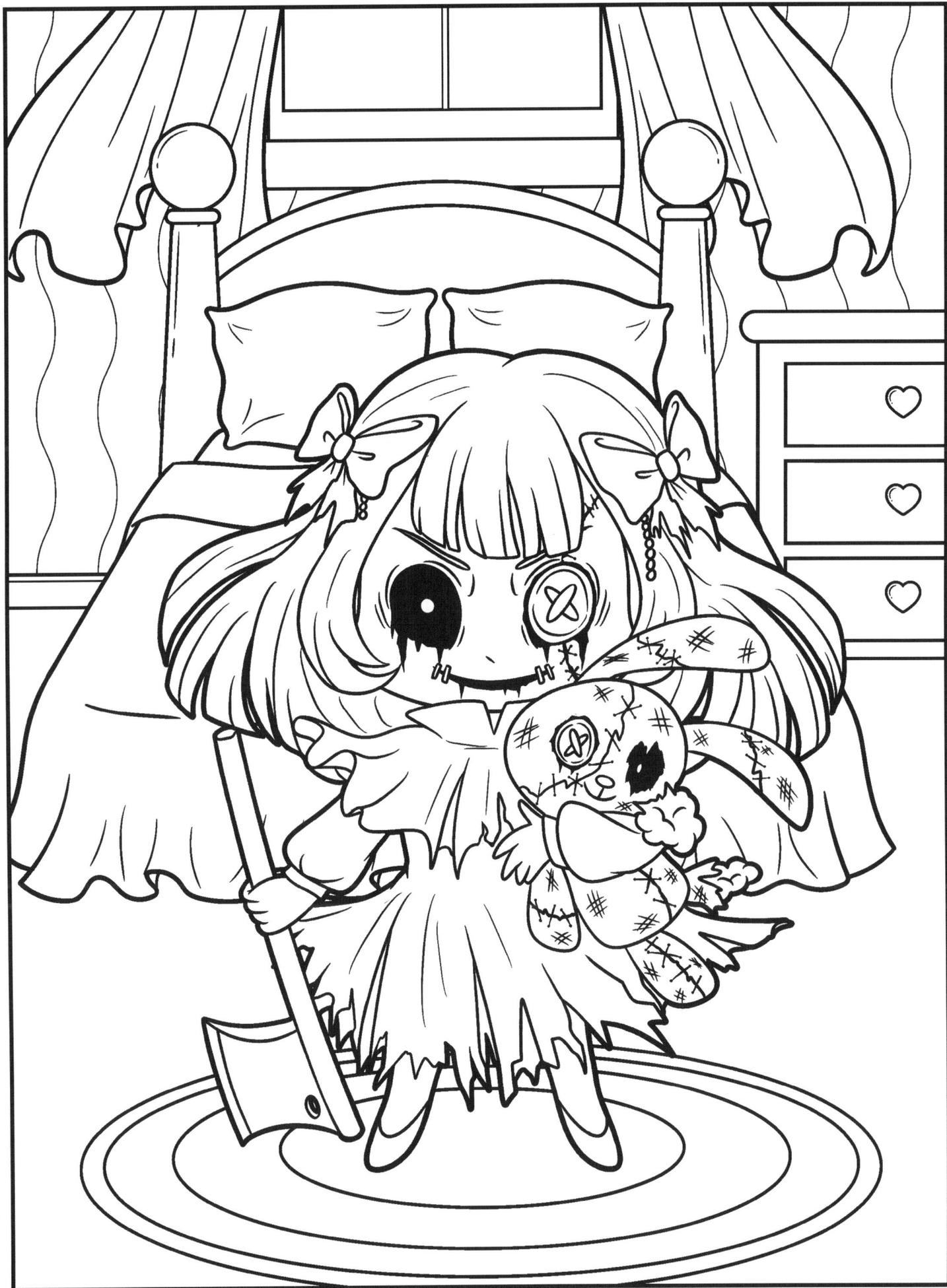

Made in the USA
Middletown, DE
16 March 2023

26934030R00029